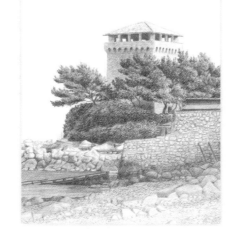

Landscapes & Vistas

By taking out the element of color and relying instead on just the pencil to craft a beautiful landscape, you can focus on the foundations of any great work of art—form, value, and design. Your greatest challenge in drawing a landscape is to not become distracted by the details, such as the leaves or blades of grass. Rather, stay faithful to the size, shape, and proportions of the major components of the scene. In the pages that follow, I will show you how to develop a landscape, from starting very simply to building up the forms and adding texture. As you follow along, I encourage you to allow your own special drawing style to develop naturally. —*Diane Cardaci*

CONTENTS

Tools & Materials

The first step for any drawing project is to gather the tools and materials you need. This process requires several decisions as to how you will work and with which materials you are most comfortable. The tools and materials detailed here will help you get started.

PENCILS

Intricate or detailed drawings call for harder leads, or H pencils. These hard pencils are labeled 9H to H, with the highest number being the hardest. Soft pencils run from B to 9B, with the 9B being the softest. These pencils create much darker lines and velvety tones. You can also choose graphite lead holders that come in different diameters, or woodless pencils, which have the advantage of a larger diameter lead.

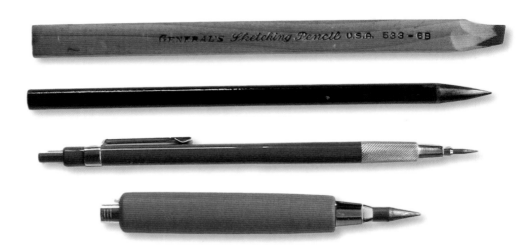

SHARPENERS

If you choose a traditional pencil, you will also need a sharpener. You can choose from small, portable handheld sharpeners as well as electric sharpeners. To sharpen the leads in a lead holder, you will need a specialized sharpener that is called a pointer.

ERASERS

My favorite eraser is the kneaded eraser. It can be molded much like a piece of clay, so you have a lot of control over what you want to erase. There are also vinyl erasers as well as electric erasers. It is also very handy to have an erasing shield, which works like a stencil and protects other parts of the drawing.

BLENDING TOOLS

There are several tools that can be used to smudge and blend graphite. A *blending stump* is a rolled piece of paper that can be used for blending so you don't get your fingers dirty. A *tortillon* is similar, but shaped differently. When you're working with a larger area, you can use a chamois cloth for blending. These are important to have on hand for creating certain textures.

USING PAPER TO YOUR ADVANTAGE

Choosing the right kind of paper for your drawing can actually save you time in the long run. Smooth paper, such as plate finish or hot press, is perfect for creating very detailed drawings. On the other hand, if you would like to have a lot of texture in your drawing, it is much easier to use a paper that has some "tooth," or texture. Textured paper, such as cold-pressed, does the work for you in creating texture. Rough watercolor paper gives you even more texture to work with. The raised areas of rough paper pick up the graphite of your pencil easily. Once you experiment with different paper types, you'll see how you can use the smooth and rough textures to help you create your drawing. (See "Choosing Paper" below.)

SETTING UP YOUR STUDIO

It is not necessary to have a fancy studio to create great artwork—many artists work at their kitchen table or in their living room. For years, I worked on a drawing board leaned against a table. If you have limited space, a table easel or drawing board is perfect. But if you are able to have a separate studio space, you will want a drawing table or easel, a cart or taboret for your supplies, and adequate lighting. I prefer to work standing up, but when I do sit, I use a studio chair that provides good back support. I have much of my studio equipment on wheels so I can move it around if I need to, and my easel, although sturdy enough for a large drawing or painting, is lightweight enough that I can bring it outdoors to work in my garden on a beautiful summer day.

CHOOSING PAPER

Here you can see how the same pencil (3B) looks on five different types of paper. It's a good idea to experiment with papers on your own too, so you can see how you can use the paper texture to your advantage in a drawing.

| *Plate-finish Bristol paper* | *Vellum Bristol paper* | *Smooth watercolor paper* | *Regular watercolor paper* | *Rough watercolor paper* |

Pencil Basics

CHOOSING THE RIGHT PENCIL FOR THE JOB

If you're working on a drawing that has a good amount of detail, remember that you'll save some time by working with hard pencils. For the detail work in my drawings, I usually use an HB and sometimes a 2H. But if you want plenty of dark, rich tones and detail is not as crucial, soft pencils are the best choice. Also, by changing the pressure, soft pencils can show greater variety in the strokes.

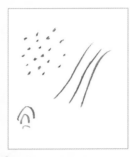 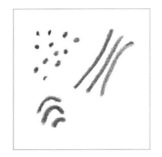

On the sample above left, strokes were created with a 5H pencil, which has a hard lead. On the sample above right, strokes were created with a 6B pencil, which has a much softer lead. You can see how the strokes of the 5H pencil are much sharper.

USING THE SIDE OF THE PENCIL

When drawing, practice creating strokes with the side of your pencil. Here, I used a 3B pencil in both strokes, but I used the side of the pencil on one (below right) and the point of the pencil on the other (below left). You can see how using the side of the pencil creates a much wider stroke, which is helpful for shading or covering more area of the paper quickly.

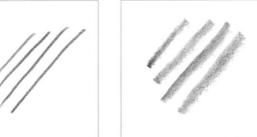

HOLDING THE PENCIL

Try holding the pencil in different ways to see how it affects your drawing. Some positions are better for detail work, while others are better for larger strokes.

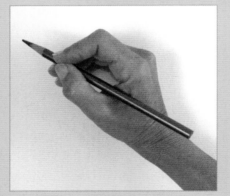 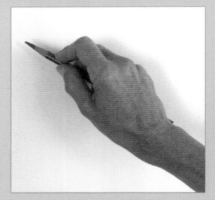 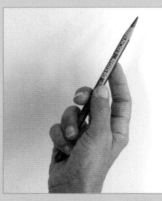

The most common position is the writing position; this is best for detail work because it involves using the small, fine muscles of your hand.

The underhand position is good for when you're using the side of the pencil. Holding the pencil this way uses more of your arm muscles, so it is also good for long, free strokes.

The overhand position is an alternative for creating long, free strokes.

QUICK AND EASY—ONE PENCIL, MANY JOBS

By using a moderately soft pencil, you can achieve a variety of effects in your drawing. These strokes were all created with the same 3B pencil. Experiment with these techniques, and then see if you can find some other new ways of using your pencil as well.

 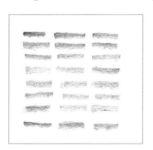

Change the pressure as you draw to give your lines energy and interest.

Use the side of the pencil to draw a pattern with straight, short lines for a shortcut to drawing bricks or patterns.

Use the point of the pencil to scribble in bushes or trees.

Scribble with the side of the pencil to indicate softer, darker foliage.

Use the side of the pencil to scribble in the darker, softer tones, and then use the point of the pencil for details in shrubbery.

For a quickly rendered brick or stone wall, combine short horizontal strokes with the side of the pencil with detailed strokes from the point.

Drawing Techniques

There are many different ways to use your pencil to create lines and textures. Here, I've demonstrated some more common techniques. Practice these and develop your own, too! Don't be afraid to switch between the point and side of the pencil for different effects. Experiment with the pressure as well as the length of the strokes. And try varying the width between strokes to create lighter or darker tones.

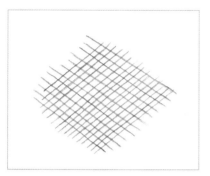

Crosshatching *Draw even parallel strokes, and then change the direction and repeat. You can even change angles several times, creating darker tone.*

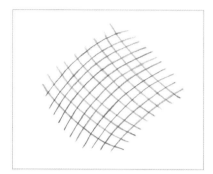

Curved Crosshatching *Make parallel strokes as with regular crosshatching, but this time curving them. These are useful to indicate the curves on a rounded form.*

Parallel Strokes *Long horizontal strokes are an option for light shading. These can be also be curved, wavy, or zigzag. Long, slightly wavy strokes are great for water.*

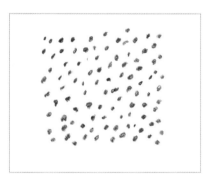

Stippling *Create dots with your pencil, using either a sharp or a dull point. Varying the size of the pencil lead or the size of the dots will change the appearance.*

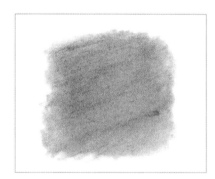

Blending with a Stump *Dip the stump into graphite powder and smear it on the paper. This is a fast way to lay down tone, also producing the effect of a wash.*

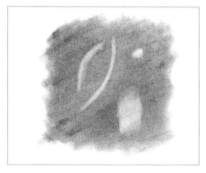

Lifting Out *Take an eraser to a toned area of paper to remove graphite. A vinyl eraser will create sharp lines, whereas a kneaded eraser will produce softer shapes.*

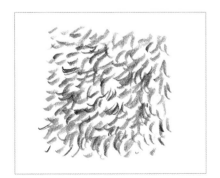

Curving Strokes *Group short, slightly curving strokes together to reproduce a very natural-looking texture, which can be useful for trees and bushes, as well as for animal fur.*

U-Shaped Strokes *Grouping many U-shaped lines together results in a sharper, more defined texture, such as what you might use for pebbles or rocks on the ground.*

Scribbling *Use random, loose scribbles for light shading of rounded forms, or tighter ones like these to create textures for leaves, dirt, or even rocks.*

EASY WAYS TO SEE VALUES

Values are the lightness or darkness of the subject—when you look at a black-and-white photograph you are seeing only the values and not the hues (colors) of your subject. It can be confusing to learn to evaluate values, but here are two simple tricks you can use to help.

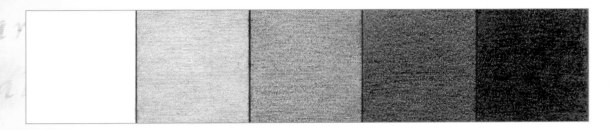

Squint *When you look at objects, make a habit of squinting and comparing the lightness and darkness that you see to a value scale. Squinting cuts down on the light entering your eyes, so the color is not so distracting.*

Black and White *If you're working from a photograph, you can make a black-and-white copy of it to help you see the values. If you are working from life, you can take a black-and-white photo of your subject and refer to it while you are working.*

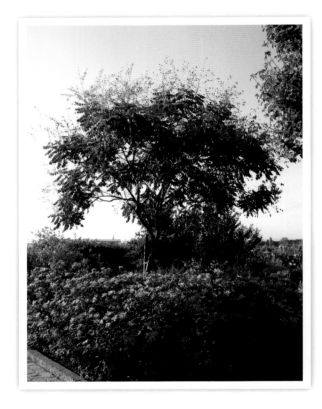

TRANSFERRING THE DRAWING

Because I like to work from basic shapes, slowly defining the elements of my sketch, I typically work out my composition sketch on a sheet of extra drawing paper, then transfer the final outline to a nicer piece of art board to finish. Transferring the sketch is simple once you understand the basics of the process.

Step One *Use a 6B pencil to completely cover the back side of your sketch paper—the side opposite the image. For an even layer of coverage, you may wish to use a facial tissue or stump to smear the graphite.*

Step Two *Next, turn the sketch right-side up, and lay the graphite side down on top of the art board you've selected for your final drawing. (Use artist tape to secure it, if you like.) Lightly retrace the lines of your sketch with a sharp pencil.*

Step Three *Check the art board underneath occasionally to be sure you're not pressing too hard. (Too much pressure could leave permanent indentations on your surface.) When you've retraced all the lines, your transfer is complete!*

Approaching the Drawing

Once you select a photograph to work from, you can begin your drawing. Rather than get overwhelmed by all the information in the photo, I start with the basics, working toward more detail gradually. I recommend that you look for large, basic shapes in your photo—for example, the overall round shape of a tree's leaves. As you're studying those shapes, take note of the proportions—is the tree trunk shape more square or rectangular? How much taller is it than it is wide? It's helpful to notice angles, too. For example, is a tree trunk leaning? Getting this basic information transferred to the page will provide a solid framework for your more-developed drawing.

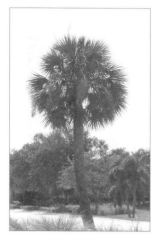 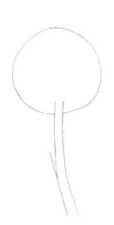

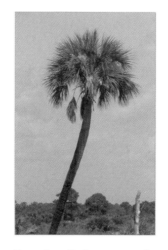

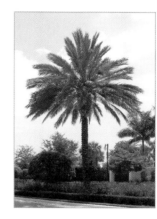 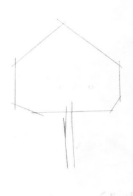

Angular Palm *For this palm, I first establish the angle of the tree trunk's base with a straight line. Then I draw a second line coming from where the trunk begins to straighten. After determining the width of the trunk and marking the lines to match, I make a large circle to represent the full set of fronds, making it proportional to the trunk. Now I have a good foundation to work from.*

Leaning Palm *Even when you're drawing the "same" subject (here, another similar palm), the shape can be quite different. Draw what you see, not what you expect to see. With this palm, the trunk is leaning more—and in the opposite direction of the first tree. The point where the tree begins to straighten out is much closer to the top of this trunk, which is also taller and thinner. And here, I need to draw a line to establish the angle of the fronds in addition to the circle that encompasses the shape.*

Vertical Palm *Here's yet another palm tree— with yet another different set of shapes, proportions, and angles. In this example, the trunk is almost completely vertical. The fronds fill out a shape similar to a triangle, but I choose to add extra lines to better establish the fronds, representing their true form. As with the earlier drawings, the particular proportions and angles of the subject are as important as the shapes themselves.*

COMPOSITION BASICS

The way the elements are arranged on the page—or the composition—is important, because it allows you to lead the viewer's eye around the page, ultimately directing it toward the focal point. You should keep these composition basics in mind when drawing or taking a photo reference. There may still be situations where you'll want to alter the composition of a photo reference or combine more than one reference, which means you'll compose on the page instead of through a lens.

Common Composition Schemes

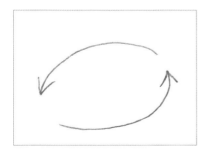 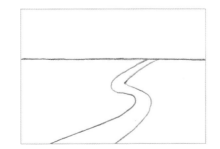 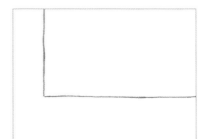 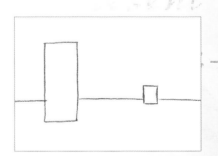

Oval *The eye travels around the picture in an oval path. Each time the eye begins to move toward the side of the picture, an element located there (such as a tree branch) redirects it back inside.*

S-shape *The eye zigzags throughout the picture, as if following a winding road. The path should not begin or end in the corner of the picture, so that the viewer's eye is not drawn out of the picture.*

L-shape *Here, a large vertical shape along the side and a horizontal shape along the bottom take up the better part of the composition. For example, there could be a large expanse of sky framed by a tree to the left and ground at the base.*

Steelyard *In this example, a small shape in the background balances out a larger one in the foreground—such as a barn directing the eye toward a country house. The two elements can't be too like in size, lest they fight for attention.*

Focusing on Shapes

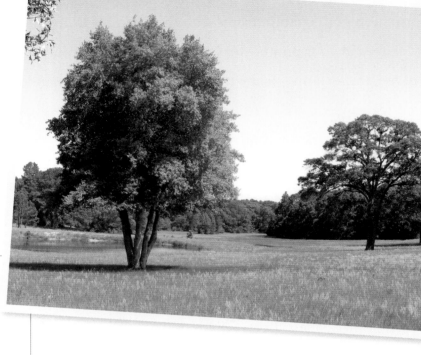

On a gorgeous spring day, my husband and I decided to go for a long, all-day car ride. I grabbed my camera and sketchbook, and we headed for the rolling hills and expansive views of Northeastern Texas. I spotted this pretty scene and immediately took some photos, knowing that they would later become the inspiration for a drawing.

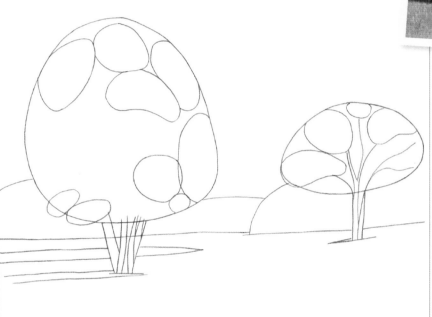

1. *Using an HB pencil, I begin by drawing two horizontal lines to establish the baseline of the background trees. Next I draw shapes to represent the two larger trees. I draw the largest, simplest groupings of leaves using smaller oval and kidney shapes. I draw and fill in the tree trunks using simple, straight lines. I draw horizontal lines to indicate the shadows cast by the trees. I add a long horizontal shape to indicate the pond behind the larger tree and three curved horizontal lines to indicate the shapes of the background trees.*

ARTIST'S TIP
When beginning a landscape, I always remind myself to simplify. By thinking of simple basic shapes, I avoid the mistake of being distracted by the thousands of individual leaves.

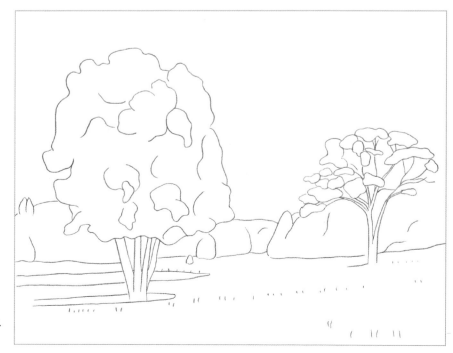

2. *I place a piece of heavyweight tracing paper over my drawing and secure it using artist tape. Still using my HB pencil, I trace the shapes from my original drawing, while focusing on making my drawing more realistic (although I don't focus on the small details yet). Next, I transfer my drawing to a piece of Bristol cold-pressed paper. (See "Transferring the Drawing" on page 6.)*

3. *Next I use a large blending stump and graphite powder to create a "wash" to indicate the large shadow areas. Using the tip of the stump, I wash in a dark value at the base of the background trees on the right side of the frame. With the side of the stump and using circular strokes and light pressure, I add a lighter value over all of the trees. When satisfied, I dip my stump into the graphite and use loose, quick circular strokes to create darker shadows in the leaf clusters on the large tree; then I use the point of the stump to add value to the trunk. I repeat this process for the smaller tree. I use the stump to create the cast shadow of the larger tree and fill in the pond. Finally, I add a touch of graphite powder to the lower right corner of the foreground.*

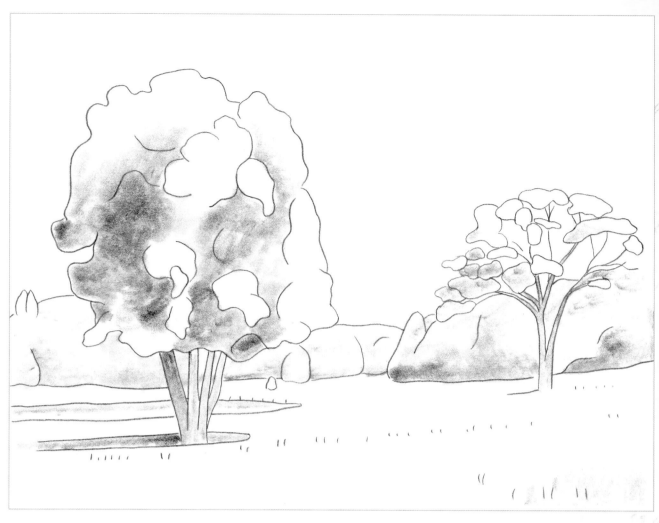

ARTIST'S TIP
Using a blending stump and graphite powder is perfect for filling in large areas when working with big shapes.

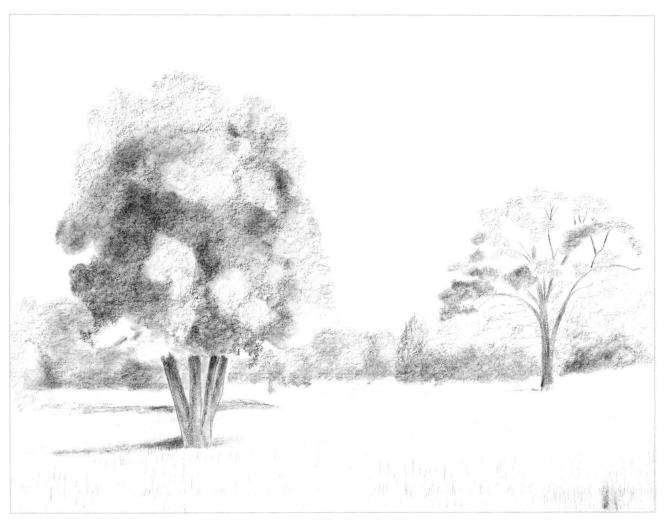

4. *Now I begin to add texture. Using the side of a 4B pencil, light pressure, and circular strokes, I add a light layer of value to the background trees, followed by a slightly darker layer for the shadows. I lightly blend the area with the stump. Using the side of my 4B pencil, I continue to add texture to all of the leaves, using light pressure in the sunlit areas and heavier pressure in the shadow areas. Next I tone the tree trunks and branches. I use graphite powder and a blending stump to create the cast shadow of the smaller tree. I add dark value into the pond, and then use long, vertical strokes with my stump to quickly lay tone into the grass. Finally, I switch to an HB pencil and, using short, vertical strokes, I draw in textured grass in the foreground.*

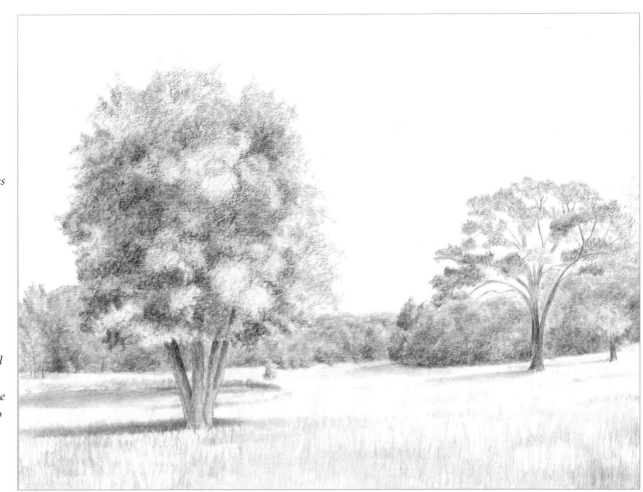

5. *With a 4B pencil I shade the background trees using very small circular strokes, continuing to use heavier pressure in the shadow areas. Using this same technique, I add more texture and tone to the tree at right. I use the point of a 2B pencil to darken in and add more branches. Next I use the 4B pencil to darken and tone larger tree trunks and branches. Using the side of the 4B, I use squiggly, light strokes to further refine and add leaves, continuing to focus on the shapes of the clusters, rather than individual leaves. I shape my kneaded eraser into a point and use it to lift out small leaf shapes around the large tree. I fill in the grass using both the stump and graphite powder, followed by the point of an HB. Finally, I add more tone to the pond and draw the trunk of a small background tree on the right.*

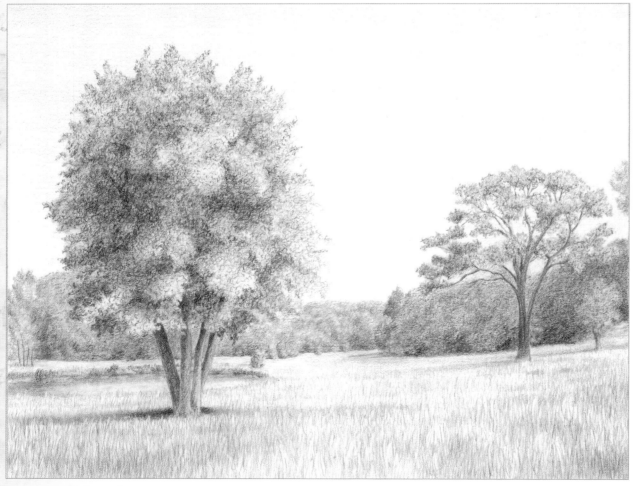

6. *In this step, I create more grass texture. Using the side and point of an HB pencil, I draw with vertical strokes, using longer strokes in the foreground and shorter strokes as the grass recedes. I build up tone slowly, adding more strokes where the grass is in shadow. I indicate the grassy areas in the distance using the side of the pencil and light horizontal strokes. I add more detail to the pond, using both the point and side of a 4B pencil. I then use the side of a 7B pencil to deepen the darkest shadows in all of the trees and background. Finally, I use the point of the 7B to deepen the trunk lines of the larger trees.*

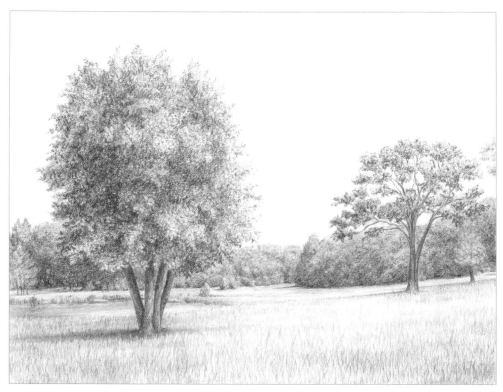

7. *I build up the foliage with the blunt point of a 4B pencil and circular strokes, deepening the background trees. Next, working with the blunt point of a 9B pencil and using circular strokes, I deepen the shadow tones of the larger trees and add a bit more tone to the lighter areas. Using the kneaded eraser, I shape the small tree on the right, adding tone with the 4B. I continue to refine the background grassy area using the side of a 4B and horizontal strokes. Using the point of the same pencil, I define the edge of the pond. I then switch to the side of a HB pencil to add tone. I add more texture to the foreground grass using a 2B pencil, alternating between the side and point of the pencil.*

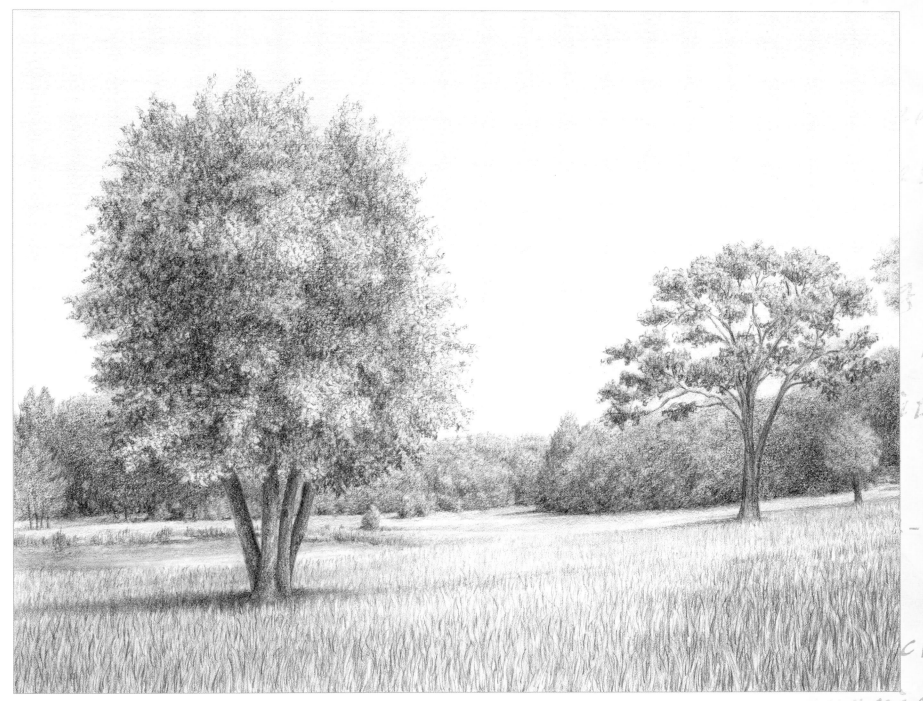

8. *In the final stage, I analyze my drawing by looking at it in a mirror, which helps me see if I need to further refine the tones. I add a bit more tone to the sky using the side of the HB pencil. I use a 2B to add more texture to the grass in the foreground. When I'm satisfied with my drawing, I set it aside for a few days. When I return to it with fresh eyes, I decide if I need to make any finishing touches before framing.*

Building the Framework

Most people think of bright, bold colors
when they think of wildflowers, but I love to render them
in black and white, because I can focus solely on the beauty
of their delicate forms. I came across these white poppies
growing along a rocky creek one beautiful spring day. The
dark value of the background trees makes a perfect foil to
show off the graceful shapes of the poppies.

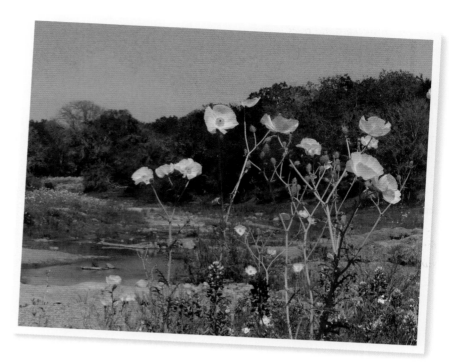

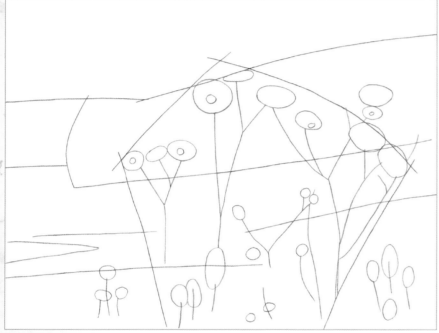

ARTIST'S TIP
*The initial lines in step 1 are like the
frame of a house—if they are not placed
correctly, the remainder of the drawing
will be disproportionate.*

1. *When drawing a complicated scene, I break it down to the most basic shapes.
Since the poppies are the focus of the drawing, I begin by sketching a large
pentagonal shape with a sharp HB pencil to block in the flowers. I then draw
a horizontal line for the rocky ledge in the left foreground and angled lines
to indicate the line of trees in the background. I add zigzag lines to place the
creek and another upward sloping line to indicate the rocky ledge in the right
foreground. I use spherical and elliptical shapes to represent the poppies, and then
place these shapes within the pentagonal shape. I draw the stems, observing how
much they lean to the right or left. I represent the bluebonnets with oval shapes on
a stem, positioning them carefully in relation to one another and to the poppies.*

2. *Using my previous sketch as a map, I begin to redraw the outlines of the
background trees on tracing paper. I add the creek and the rocky ledge. I work on
the poppies by first drawing the main stems and then moving to the petals, focusing
on their major shapes. Lastly, I draw the remaining stems and the small buds. For
the bluebonnets I use small, u-shaped strokes to re-create the flower clusters. I then
transfer the drawing to a clean piece of hot-pressed (smooth) Bristol board.*

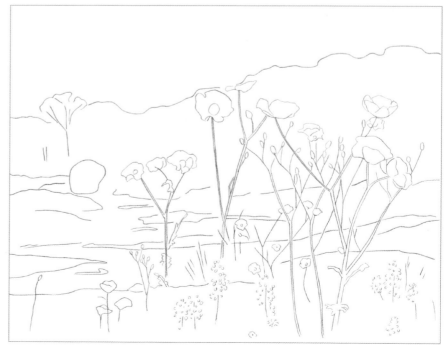

3. *I study my photo reference, squinting my eyes so I can see the major values in the scene. The darkest value is the background trees, so I dip my blending stump into some graphite powder and smear it in the tree area with circular strokes. I work quickly, using small and large circles, to create a random effect. I use the point of the stump as I approach the flowers. Then I add another layer of tone to the trees to create a darker value. I then add some graphite to the middleground, using less pressure and graphite because it is lighter in value. In the foreground, still using the side of the stump, I use quick vertical strokes to create a base for the darks.*

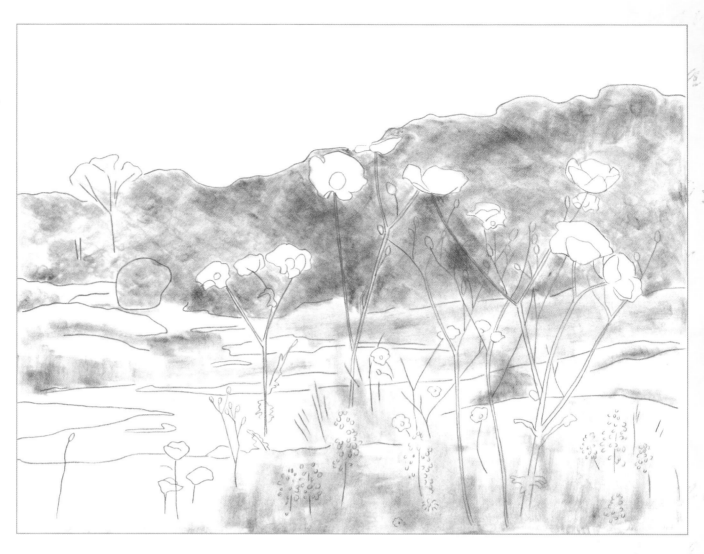

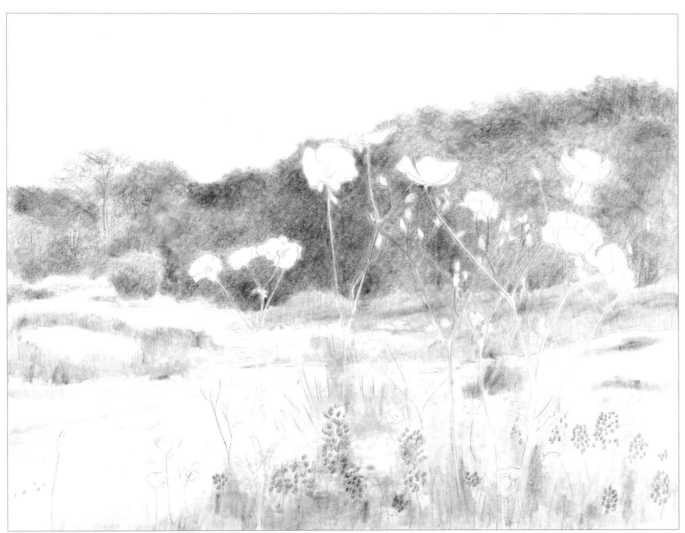

4. *Next I use the side of a 2B pencil and circular strokes to lay down some leaf texture on the background trees. In the shadow areas, I use the same technique, but apply more pressure so the paper picks up more graphite. I use vertical strokes with the side of the 2B over both the grassy and shadow areas of the back and middleground wildflowers. I add a light layer of graphite to the creek, using horizontal strokes and light pressure with both the stump and pencil. Using the point of an HB, I refine the shapes and details of the poppies. I clean unwanted smudges with my kneaded eraser. With the HB, I work on the foreground, using long, slightly curved, vertical lines to establish the weed texture. I then use the tip of a 2B to fill in the bluebonnets.*

5. *I switch to a large-diameter 6B pencil to deepen the tones of the background trees. I still use circular strokes and alternate between using the blunt point and the side of the pencil. I also use heavier pressure in the shadow areas. Next I add vertical strokes with a 2B over the grass and shadows of the wildflowers in the middleground. I use the lightest touch and circular strokes to create the texture of distant wildflowers. I add more details to the small rocks near the creek and build up more weed texture in the foreground using the point of the 2B and long, vertical strokes. Then I switch to my blending stump and add light tone to the water, using horizontal strokes. I use the tip of the stump and a small amount of graphite to add light shadows to the poppies.*

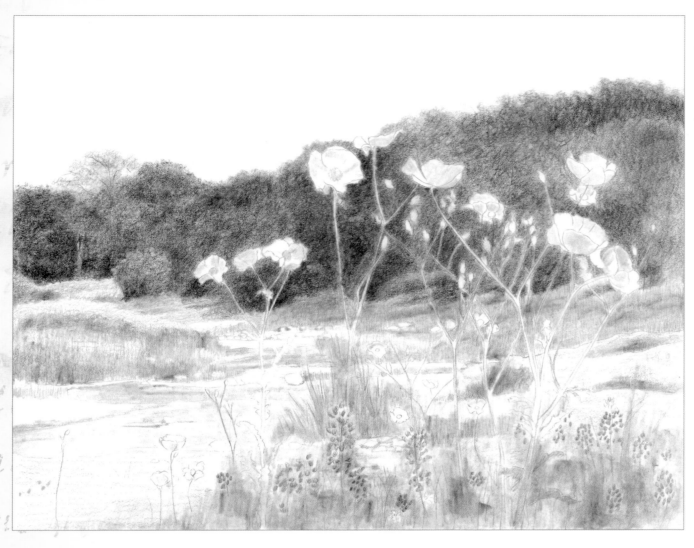

6. *I further add value and texture to the background trees using 4B, 7B, and 9B pencils with circular strokes and the "stippling" technique (see page 5). I randomly dab my kneaded eraser to pick up graphite, lifting out branch shapes. I also use my kneaded eraser to clean up areas by the poppies; then I redraw the flowers where necessary with a sharp HB pencil; then I carefully shade them using a light touch, drawing slightly curved lines that follow the form of the petals. I then stipple the center of the poppies with a 2B.*

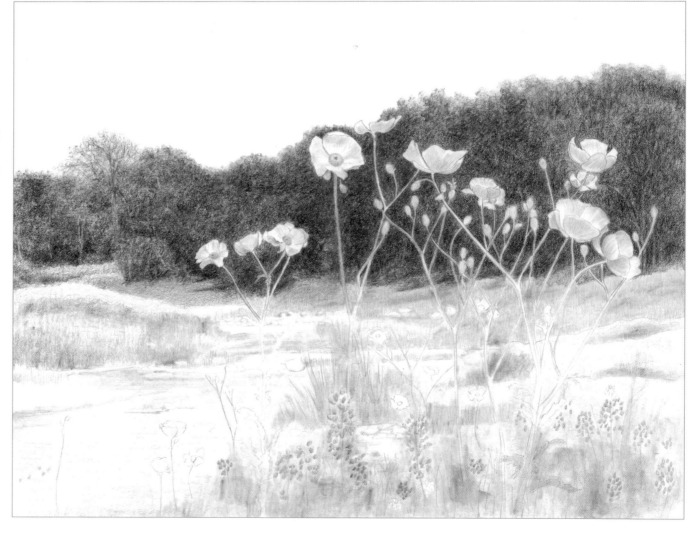

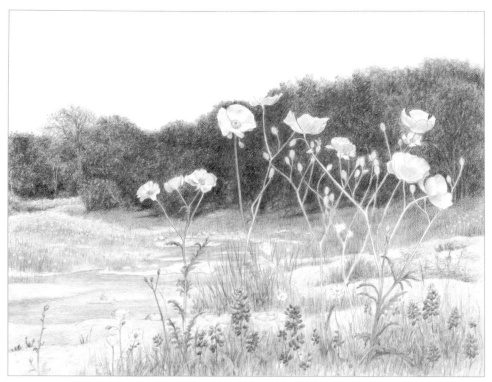

7. *I use a 4B to apply short, vertical strokes to deepen the value in the grassy area and in the distant wildflowers. I then create a small point with my kneaded eraser and pick out small flecks of graphite, adding texture to the wildflowers. I use the point of a 2B to add more detail to the creek, and use horizontal strokes with the side of the pencil to darken the water. To develop the rocky ledge, I use the side of the 9B and lightly skim the surface of the paper so that it picks up specks of graphite, using slightly heavier pressure in darker areas. Then I use the side of a 4B to build up more dark value in the foreground weeds. For the many branches and grasses, I use the point of a 2B pencil to make long and short vertical strokes. I also use the kneaded eraser to lift out irregular grass shapes. To add more detail to the bluebonnets, I use the point of a 4B. I pick out some highlights in these flowers with the kneaded eraser, as well.*

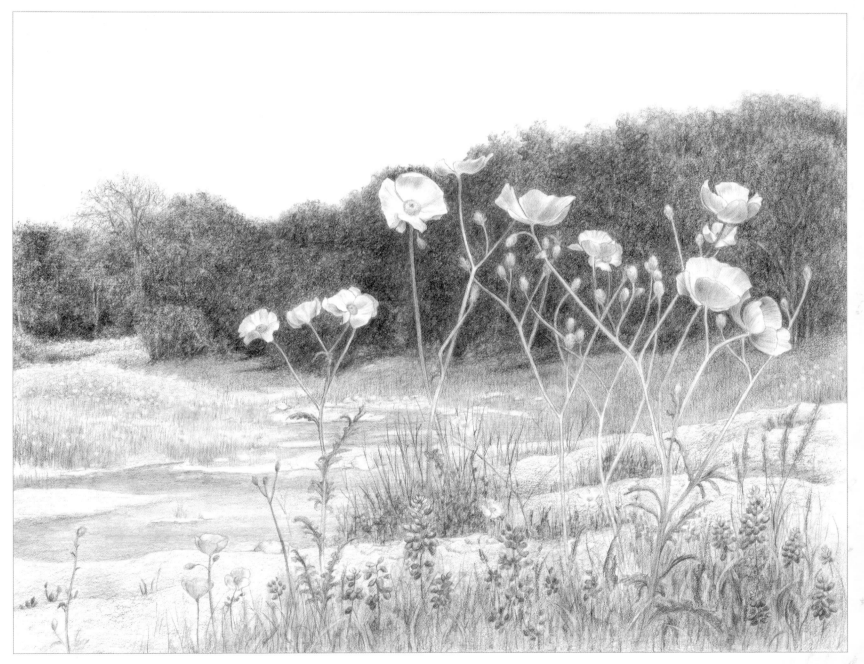

8. *I place a large piece of tracing paper over the drawing to protect it from smudging. Then I add light tone to the top of the sky by making long, horizontal strokes with an HB and light pressure. I remove the tracing paper and refine the shading of the poppies, using 2H and HB pencils. I use the kneaded eraser to pick out highlights throughout the drawing. Then I deepen the water with the side of a 2B and blend lightly with a stump. I use the kneaded eraser to add lighter areas and reflections in the water. Next I darken the foreground, using the 9B for the rocky area and the side of the 4B for the weed area. I create more weed texture using both the sides and the points of the 2B and 4B. Finally, I look at the drawing in a mirror and decide to eliminate some smaller flowers in the middle and foregrounds.*

Creating Texture

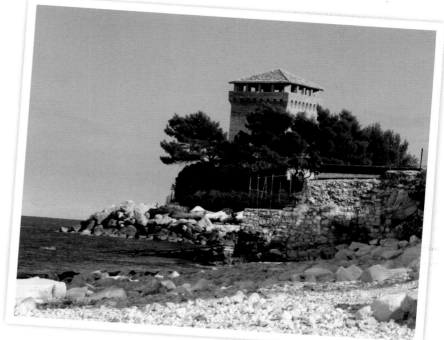

When I visit the coast, one of my favorite activities is strolling along the water's edge. I admired how this old medieval structure seems to grow out of the natural forms of this coastal scene and decided the view was something I wanted to capture in a drawing. In addition, the contrast of the white rocks against the dark values of the foliage creates an interesting design.

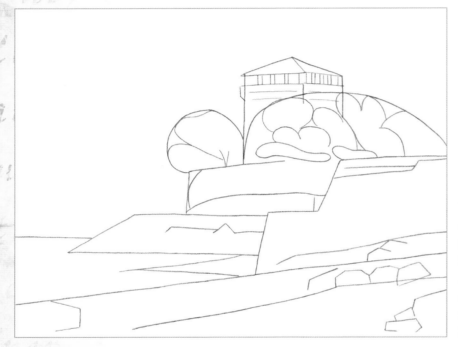

1. *I begin by blocking in the basic shapes with an HB pencil. I establish the lines of the rocky beach, the ledge, the rock wall, and the water. I draw the basic shape of the protruding jetty and the boat ramp, and I add lines to place the basic shape of the tower. I then add curved lines to envelop the bushes and trees; then I draw large and small shapes to represent the foliage. I block in the larger rocks and add a line in the foreground to establish the long cast shadow across the beach.*

2. *I tape a clean piece of heavyweight tracing paper on top of my drawing. Then I begin to redraw the scene, starting with the tower and adding the arch detail toward the top. I trace the upper level of trees using flame-like shapes and the lower level of foliage using wavy lines. The jetty, wall, and beach are challenging because there are so many rocks. I concentrate on the prominent ones because I am more concerned with texture than replicating my photo. The jetty is an important focal point in the composition, so I add more rock detail in this area.*

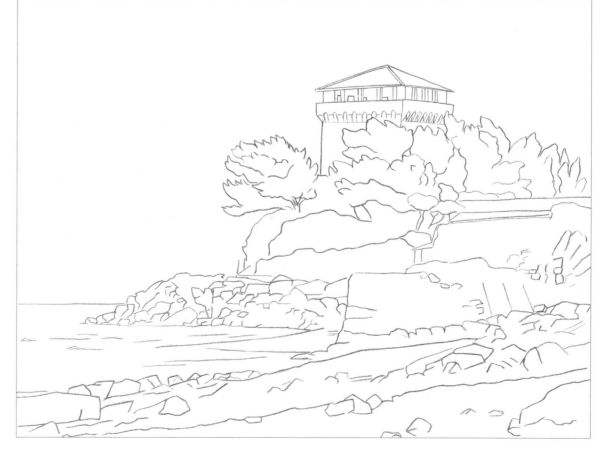

3. *I transfer my drawing to a clean piece of cold-pressed vellum Bristol paper, redraw the lines, and clean up unwanted smudges. I dip a large blending stump into graphite powder and apply a wash of tone to the foliage area with small circular strokes. I add more graphite to the shadows in the trees, and I use the tip of the stump to add the dark shadow under the tower's roof. There's a little graphite left on my stump, which is perfect to add a light shade of gray tone to the left of the tower. Next I pick up more graphite and add tone to the jetty with random strokes and medium pressure. I use the side of the stump to lightly tone the water with horizontal strokes. I also use horizontal strokes for the rock wall and add more graphite for the darker value at the bottom of the wall and the boat ramp. Lastly, I add light tone to the cast shadow on the beach, using horizontal strokes and light pressure.*

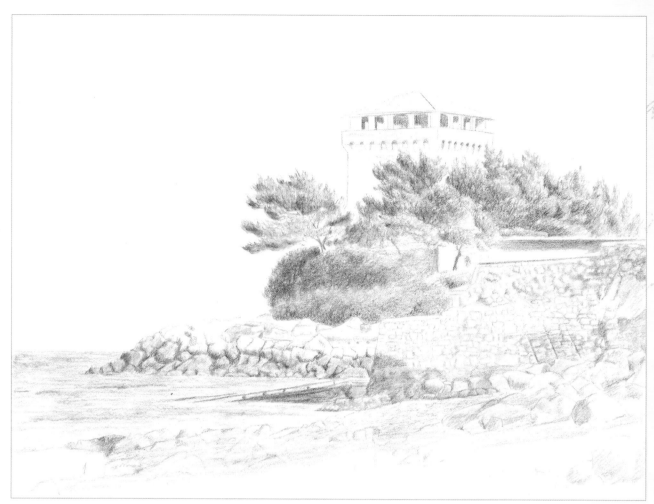

ARTIST'S TIP

I chose cold-pressed vellum Bristol board for this project because its rough surface will help me render the different textures in the composition.

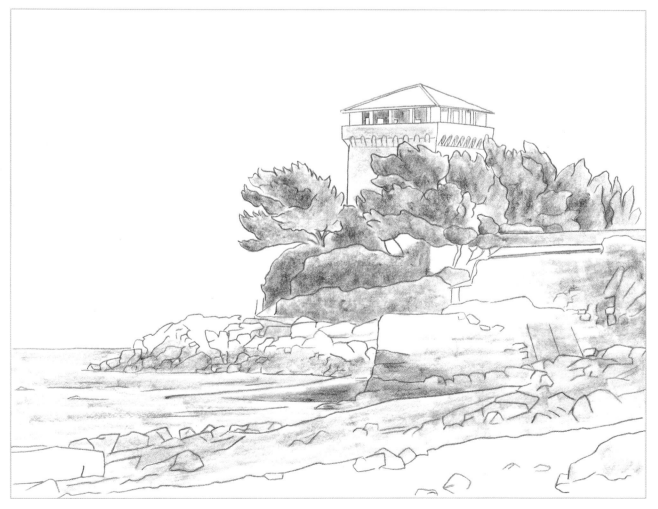

4. *Using the point of an HB pencil, I add small shadows in the tower's arches. I add texture to the walls with horizontal strokes and irregular pressure, using the side of the pencil. With a blunt point, I add short curved and straight strokes to the upper trees. On the lower foliage I make small, circular strokes with the blunt point. I deepen the tone in the shadows of the trees and bushes by adding strokes. Then I draw more rock details by the jetty, using short strokes with the pencil point. I work on the wall and boat ramp, drawing the rocks in more detail and adding more shading. Then I work on the beach, drawing the larger rocks. I darken the cast shadow by using long strokes with the side of the pencil.*

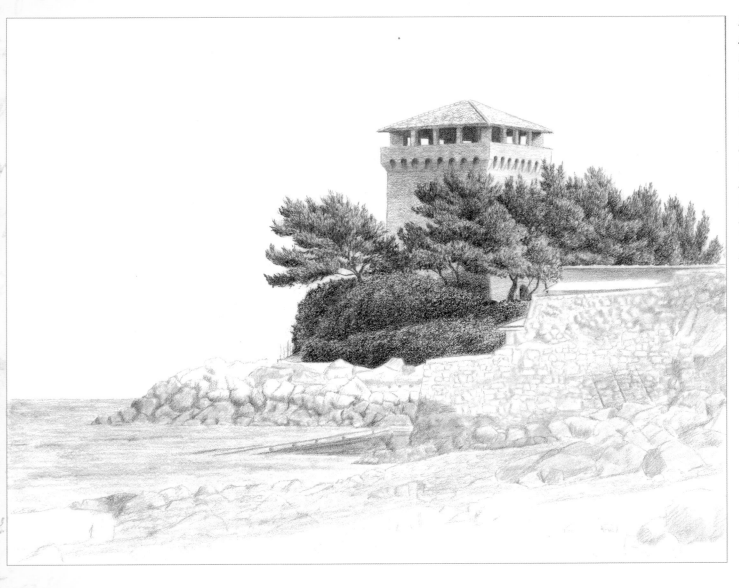

5. *I refine the drawing using softer pencils. I start with the tower, using the side of a 2B to deepen the shading. I use irregular pressure to simulate rough stone. Next I work on the trees using short strokes and a sharp 2B. I go over the shadows again with a sharp 6B. I work on the lower bushes, drawing circular strokes with a blunt 2B. Then I deepen the value and shadows with a blunt 6B.*

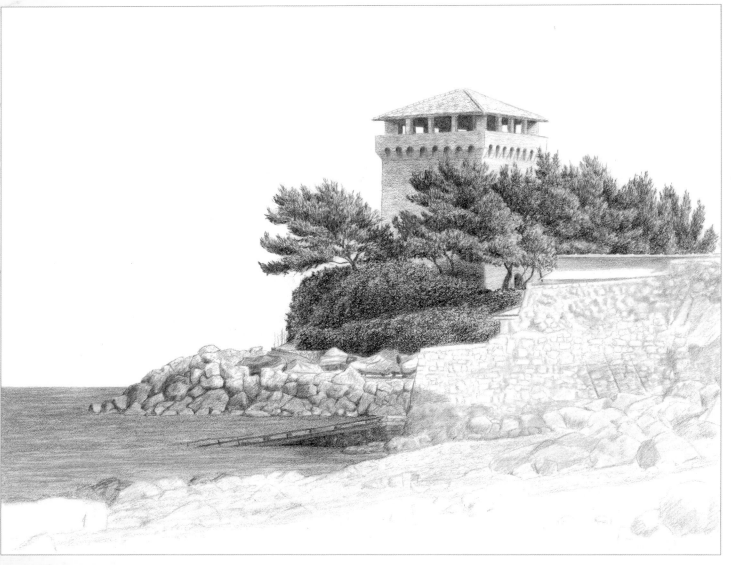

6. *For the jetty and water, I use the point of a 2B to draw the deep shadows where the rocks meet. I shade the rocks using straight, short lines in the direction of their planes. I use the side of the 2B to create another layer of deeper tone in the lower part of the jetty. At the top of the jetty, I use a sharp HB to shade the covered boats, without including too much detail. I work on the water using the side of the 2B and long, horizontal strokes. I use the edge of an eraser to pick out light, horizontal lines.*

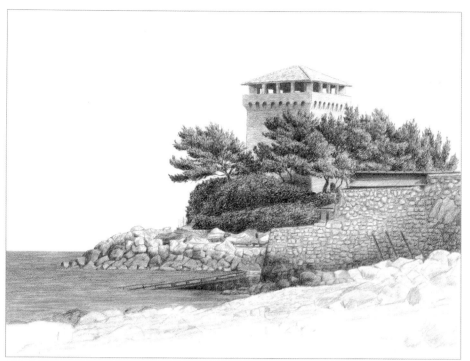

7. *I reinforce the rocks in the wall with the point of a 2B. At the bottom of each rock, I increase the pressure to create the illusion of shadow. I then use the side of the pencil to lightly add more tone to the wall, using circular strokes. As I near the bottom, I use heavier pressure and both the sides and points of the 2B and 6B pencils. At the top of the wall, where the roof of the hidden boathouse is showing, I follow the roof direction and shade with the point of an HB and a "crosshatching" technique (see page 5). I deepen the shadows under the roof with the point of the 2B. I also use a very sharp 2B to draw the three beams that support the bottom of the wall.*

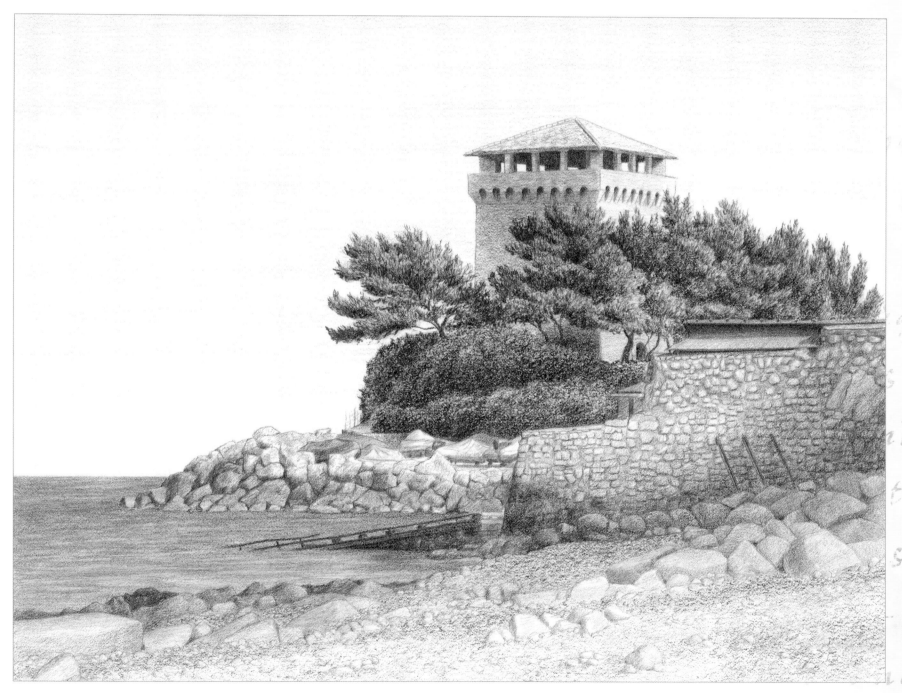

8. *Rather than focus on the details of the rocks on the beach, I use the rough paper and pencil to create texture. First I shade the larger stones and boulders with the side of the HB pencil making short, parallel strokes. I use the point to reinforce the shape of individual rocks. I then switch to the 6B and use the side to create long strokes to shade the cast shadow, stippling in additional tone to add more texture. I do the same in the sunlit area, using minimal pressure so the paper picks up light tone. I add some u-shaped strokes and irregular shapes to create the illusion of smaller rocks. I turn the paper upside down and add a light tone to the sky with the side of an HB. I use long, horizontal strokes, allowing them to fade as I work toward the water. I use the kneaded eraser to pick out highlights in the rocks and areas that are too dark.*

Combining References

I am intrigued by the centuries-old structures that are scattered throughout the countryside in Tuscany, Italy. They meld seamlessly with the cypress trees and rolling hills that are so characteristic of this region. I found the picture on the left in my files and returned to the site to do some additional sketches. I was pleasantly surprised to find that springtime had enhanced the scene by adding flowers, which gave a pretty design element. The lighting in the original photo was better, so I referenced that when doing the final drawing.

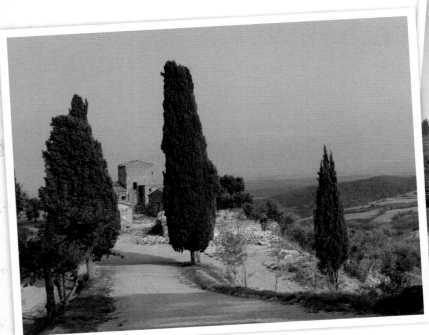
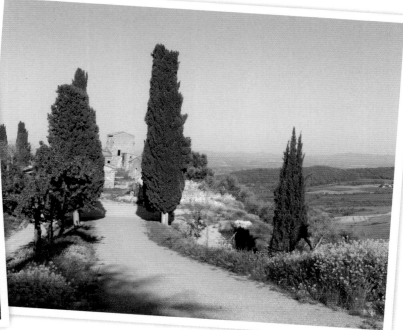

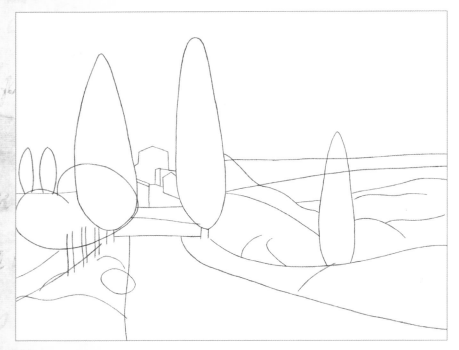
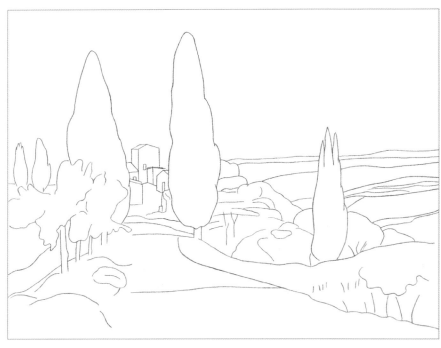

1. *I begin with a "basic shapes" sketch. To represent the three large cypresses, I draw three large ovals and their trunks. I indicate the shape of the road and the low mountains and hills in the background. I draw a few curved lines and circles to represent the grass and flowers growing alongside the road, as well as the paths. I draw a large, round shape to envelope the tree foliage on the left. I draw three trunks and small ovals for two cypress trees. Finally, I block in the structure between the large cypress trees.*

2. *I tape a clean piece of heavyweight tracing vellum over the initial drawing and redraw. Referring to the lighting reference, I draw the shadows that cross the road. I make the tree trunks more realistic and sketch in some tree foliage. I refine the edges of the larger cypress trees. Next I add the structure's details, such as the roofs, windows, and a door. I further define the shapes of the rolling hills and farmland. I work on the middleground hill, adding the forms of the old, stone wall and distant flowers. Once satisfied, I transfer the outline to a clean piece of plate finish (hot-pressed) Bristol board.*

3. *I study my photo reference and squint my eyes to see the value patterns. Dipping a large diameter stump in graphite powder, I quickly smear in a vertical wash of dark tone on all the cypress trees. I deepen the tone on the left side of the trees to establish the shading. Using long, horizontal strokes, I add tone to the cast shadows on the road. Still working with the stump and graphite, I use up and down strokes on the grass area to the right of the road. Using light pressure, circular strokes, and a touch of the graphite, I add a light gray value to the tree foliage on the left. I then use "scribbly" strokes with the stump to add tone to the distant hill and the line of trees on the hill behind the road.*

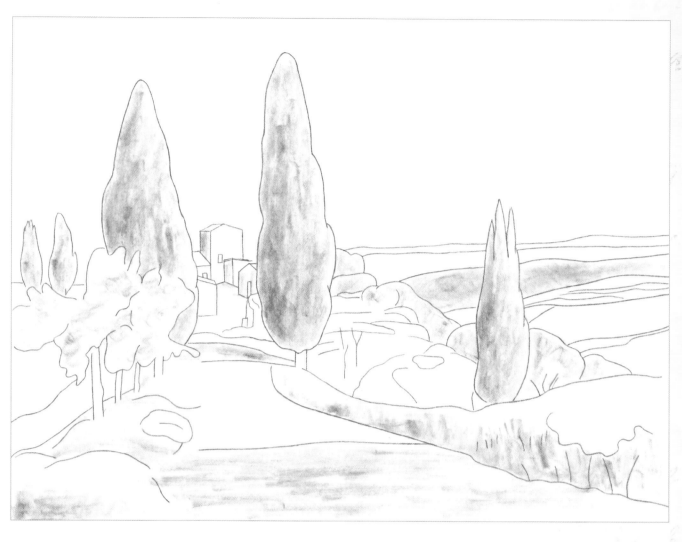

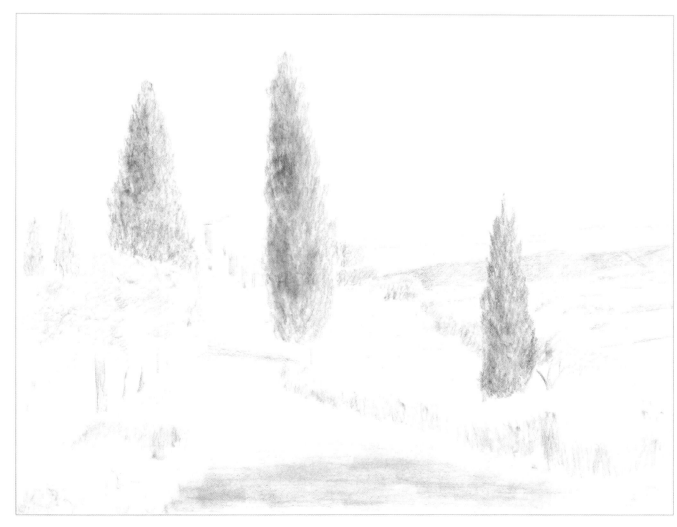

4. *I use the side of an HB pencil and long, horizontal strokes to create the light value of the mountains and farmland. I switch to the side of a 2B and, with circular strokes, shade the distant hill. Still using the 2B, I "scribble" to add texture to the trees on the hill. I then use heavier pressure and the side of the 2B to work on the cypress trees. Working quickly and irregularly, I use short strokes that follow the direction of the needle growth. I do the same for the distant trees, using lighter pressure. I switch to the HB and use circular and "scribbly" strokes for the tree foliage in the foreground. I add some light texture to the hill with short up and down strokes. Finally, I work on the old buildings with short, light strokes.*

5. *I use the side of the HB to deepen the tones of the distant hills and use the stump to smooth it out. With the side of a 2B, using heavy pressure and a short, up and down motion, I add a deep value to the distant hill. Next, I work on the buildings, first using irregular pressure and short horizontal strokes on the side of the buildings. I then use heavier pressure on the sides of the building that are in shadow. I use the side of the 4B to add texture to the ground area around the buildings. I also use the 4B to stroke in deeper tone to the two distant cypress trees.*

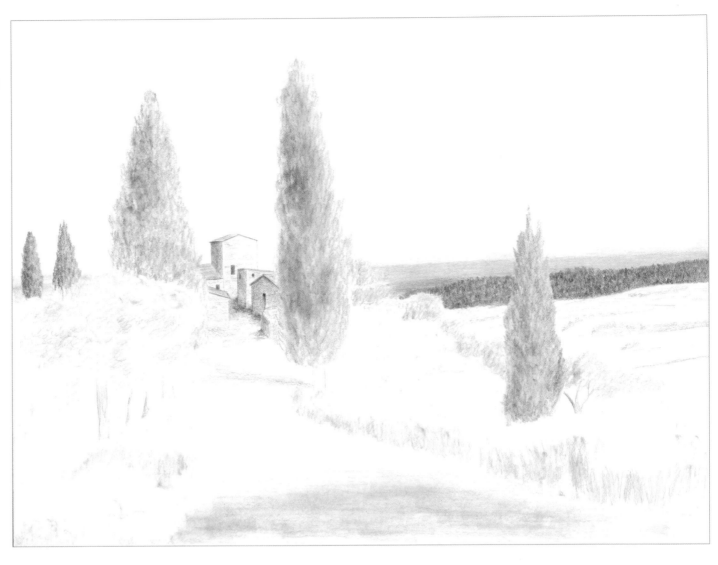

6. *In this step I work mostly on the three larger cypress trees. I work first with the side of the 2B with short strokes that go in the direction of the needle growth. I use varying pressure to create a natural-looking texture. As I work toward the edges, I extend some strokes beyond the outline to appear more realistic. I switch to the 4B, with both the side and point, to deepen the shading. I then use the edge of an eraser to lift out the shape of the tree branches in front of the cypress tree. I also lift out additional texture on the cypress trees with the eraser. Next, I use vertical strokes with the 2B to shade the trunks of the two large trees. Lastly, I use the side of the 2B to add some light shading to the road.*

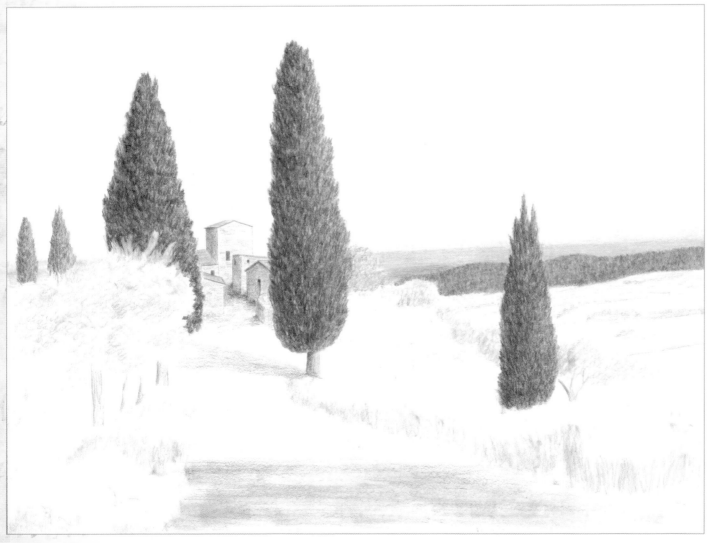

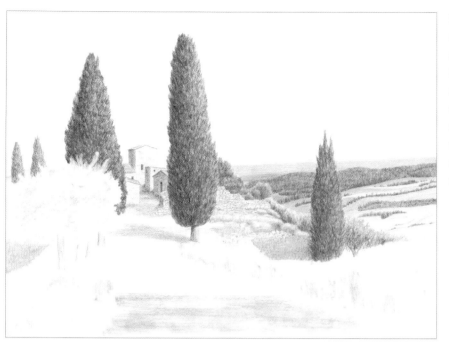

7. *Working on the background farmland, I use the side of the HB to create a light, smooth value. I use long strokes that follow the form of the rolling land, leaving some areas almost white. Next, I use the 2B to create the rows of the distant trees and bushes by using short up and down strokes. I then begin drawing the details of the stone wall using a sharp HB. I do this quickly and irregularly, so it doesn't have a mechanical appearance. I add some light texture with the side of the pencil. To create the texture of the line of trees on the hill, I use both "scribbly" and up and down strokes with the point and the side of the 2B. I use short up and down strokes to add the grassy area, and lift out tone with a kneaded eraser to create the lighter shade of the distant groups of flowers. I use the side of the 2B to lightly add texture to the path.*

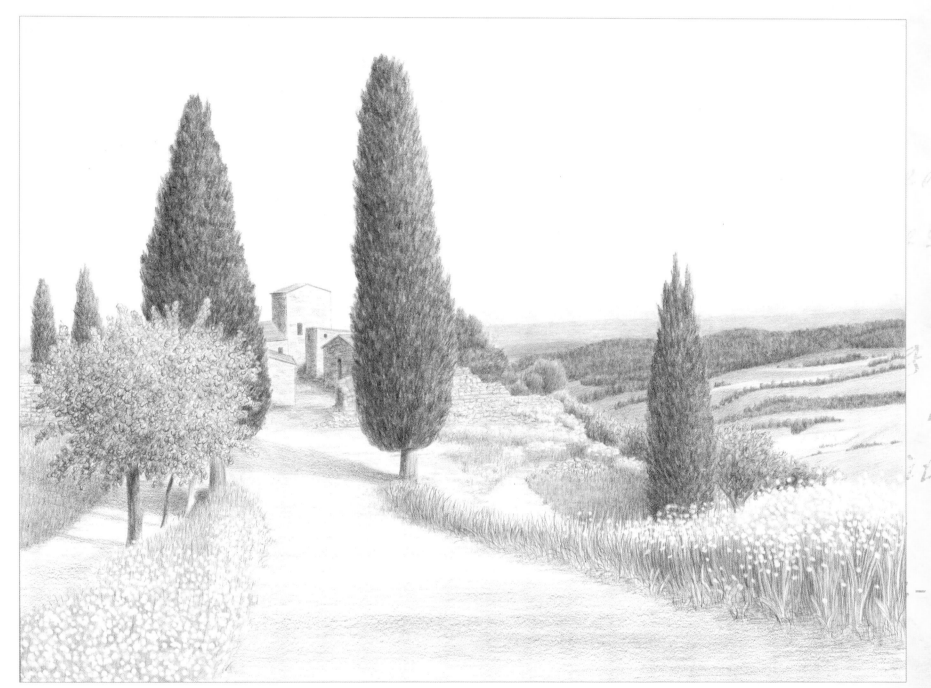

8. *In this final stage, I have fun working on the foreground to pull the drawing together. I start with the foreground tree on the left, using a 2B pencil. I alternate between adding circular strokes with the side of the pencil and u-shaped strokes with the point. I build up the shading while still thinking of the foliage as a mass. I then use the side of the 2B and the side of the 4B to shade both the road and the path to the left. I use the point of the 2B to draw the grass, using vertical and slightly curved vertical strokes to build its texture. I also use the side of the 2B to add more tone to the flower area. I then use a small battery powered eraser to lift out small dots of white to give the illusion of the flowers. Next, I turn the drawing upside down and add an extremely light layer of tone to the sky.*

Creating a Realistic Drawing

Walking along a cool mountain stream

is inspiring and exhilarating. The deep, dark green of the forest against the lighter values of the stream and its rocky embankment caught my attention one early summer day. Upon taking several pictures, I chose this one to use as my reference photo because the receding mountains create a feeling of depth. The many trees and rocks will be challenging to depict; texture will be the most important tool in creating a realistic drawing.

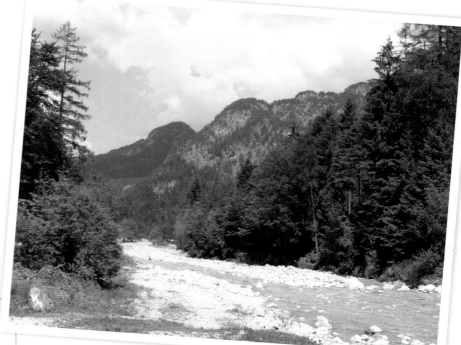

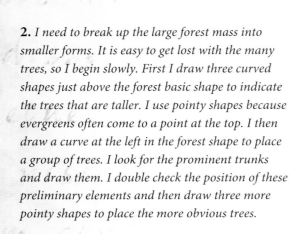

1. *I draw the large forms, including shapes to indicate the large bush and grass, as well as the vertical line to represent the main trunk of the evergreen tree. I draw an almost horizontal line as the base of the forest, as well as lines for the river.*

2. *I need to break up the large forest mass into smaller forms. It is easy to get lost with the many trees, so I begin slowly. First I draw three curved shapes just above the forest basic shape to indicate the trees that are taller. I use pointy shapes because evergreens often come to a point at the top. I then draw a curve at the left in the forest shape to place a group of trees. I look for the prominent trunks and draw them. I double check the position of these preliminary elements and then draw three more pointy shapes to place the more obvious trees.*

3. *I tape a clean piece of heavyweight vellum tracing paper over my preliminary drawing. While referring to my photo reference, I begin to redraw the outlines for the scene. I draw the river, using more natural lines. I draw some of the larger rocks in the right foreground, keeping their shapes simple. I break up the foreground shape by drawing the grassy area, the boulder, and the large bush. I draw the distant mountains and sky using more realistic lines. For the most prominent evergreen trees, I use vertical lines to represent their trunks and curved lines to indicate branches and needles.*

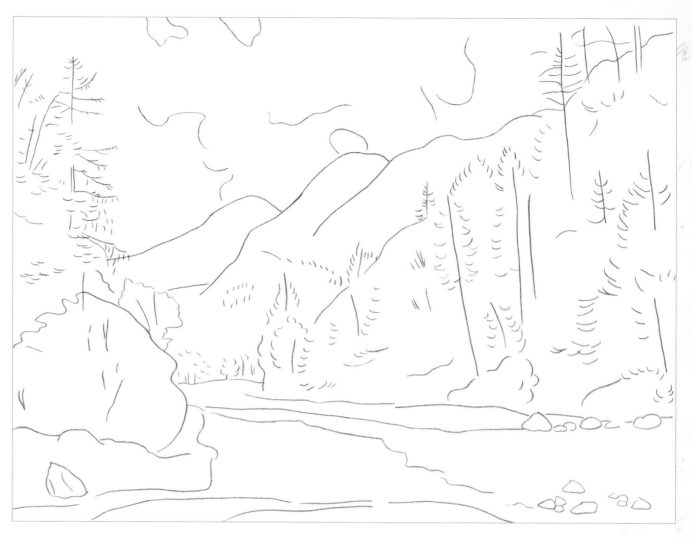

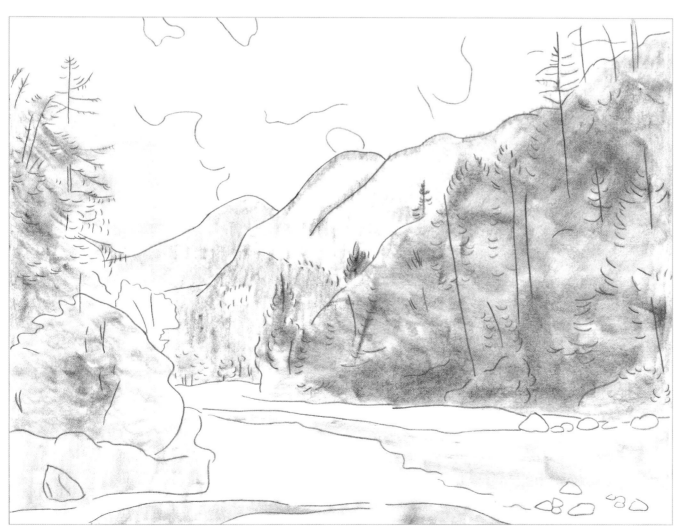

4. *I transfer the drawing to a clean piece of vellum (cold-pressed) Bristol paper. Working with a large stump and graphite powder, I add a wash of tone. Because texture is important, I ensure that the strokes are visible. In the grassy foreground, I use short vertical strokes. Working on the bush to the left, I add circular strokes and extra graphite in the shadow area. I then work on the trees to the left, using short, curved strokes that follow the direction of growth. I work on the distant mountains, using light pressure and up and down strokes. I use light pressure and long strokes in the river area. I use heavy pressure and lay repeated washes of dark tone on the forest, changing direction irregularly. With the remaining graphite left on the stump, I add light shading to the sky.*

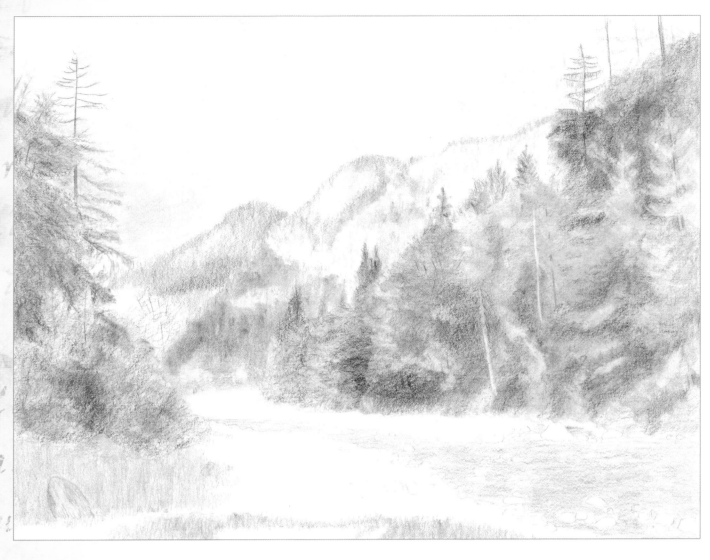

5. *Using my 2B and short up and down strokes, I add tree-like texture to the distant mountains, using heavier pressure in the areas where I want to deepen the tone. I use mostly angular strokes, following the direction of growth. I deepen the shadow areas using a 4B; then I use a kneaded eraser to lift out the lights and some tree shapes. I also add more texture using some circular strokes with the side of the 4B. I work on the tall trees to the left using slightly curved strokes with the side of the 2B. Using the point of the 2B, I draw the trunks and smaller branches and begin laying in grass texture with light up and down strokes. Finally, I use the side of the pencil and horizontal strokes to fill in the river. I work on the sky with an HB pencil. I use light pressure and a rag to smooth out the strokes and pick up excess graphite.*

6. *Next I work delicately in the sky area, using the side of the 2H and HB pencils to shade, a rag to lightly blend the strokes, and a kneaded eraser to pick out the lights. I continue to work on the mountains using the point of an HB and short up and down strokes. I add some darker strokes with a sharp 2B so that the texture in the middle mountains is evident. As I work, I allow the strokes to move beyond the original outline. I then work on the tall trees to the left. For the evergreen, I use the sharp point of the HB for the needles and branches. To create the non-descript leaf texture, I use scribbly strokes with the side of the 2B and deepen the shadows with the blunt point of a 9B. I switch to the side of a 4B to shade the large bush in the foreground, using scribbly strokes.*

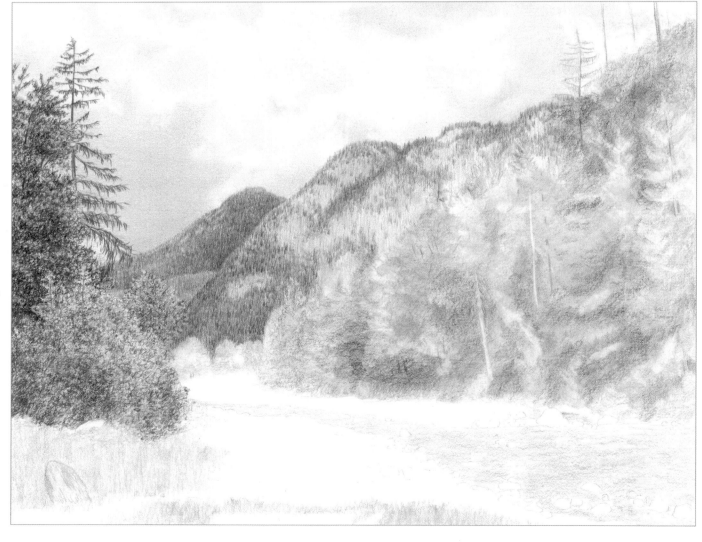

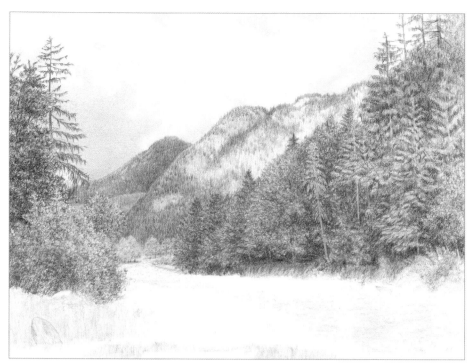

7. *Using light pressure and the side of a 2B, I build up the forest texture, starting with the most distant trees behind the river. For the areas that contain more deciduous trees, I use circular and u-shaped strokes. For the evergreens, I lift out with the kneaded eraser and use short strokes with a sharp 2B. I build up the textures, using heavier pressure and a 6B and 9B in the shadows. If I get too dark, I use my kneaded eraser to lift out. I use the point of a 2B to pick out branches and draw the visible trunks.*

A R T I S T ' S T I P
Think of the forest as being made up of value and texture rather than individual trees.

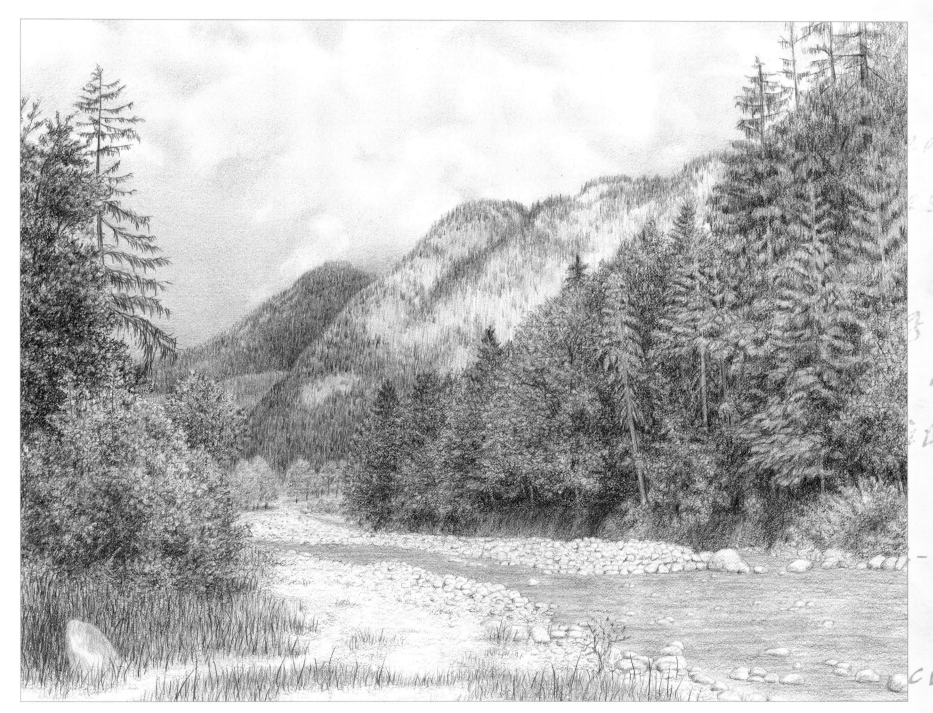

8. *I use the side of the 2B to add more tone to the river, using horizontal strokes. I do not create a smooth tone; rather, I allow lighter areas to show through. I then use a sharp HB to add small, irregular shapes to create the rock texture. As the rocks recede, I make smaller shapes that fade out. For the most distant rocks, as well as a tool for texture over all the rocks, I lightly drag the side of a 4B over the paper. Using a sharp 2B, I add vertical strokes that curve in different directions to create a natural texture for the grass.*

Adding the Details

I found this medieval fortress in the town of Volterra, Italy, and immediately began taking pictures. It's not every day I come across a pretty park and a well-preserved castle in the same eye-catching scene! When I am traveling, I often do not have time to sit and sketch, so my digital camera is always with me. Later, when I am in my studio, I frequently refer to my photo collection to refresh my memory of the places and scenes I have visited. This way, when I have days that I prefer to work indoors, I can always find an inspirational photo reference. Since this scene has so much detail, I remind myself to begin slowly and stay focused on the largest shapes and proportions.

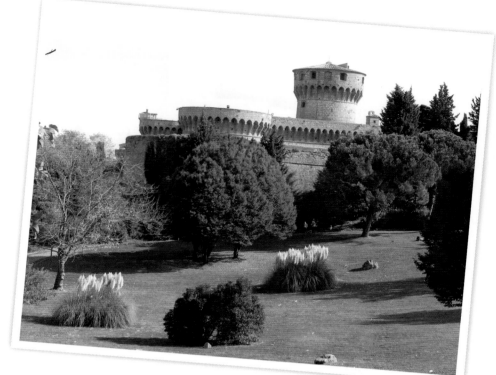

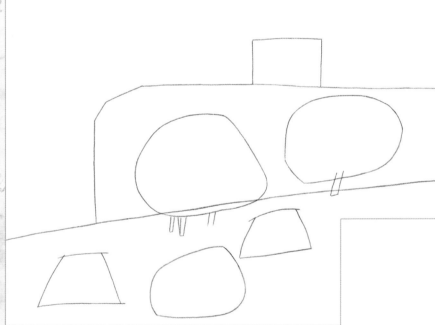

1. *As done previously, I block in the basic shapes of the scene.*

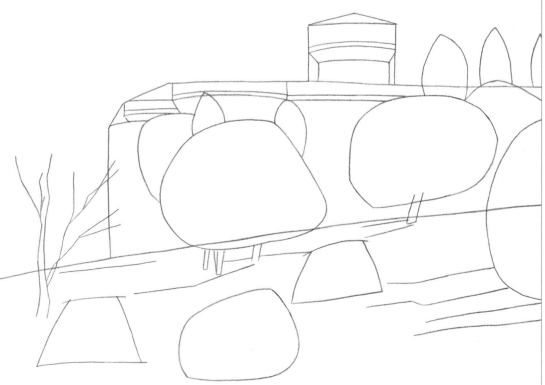

2. *I carefully begin drawing the details, using simple lines. I draw horizontal lines to act as guidelines for the arches and supports in the towers. I draw a curved shape to represent the ivy growing on the castle. I draw more curved lines to represent the other large trees. Lastly, I draw five pointed shapes to place the evergreen trees.*

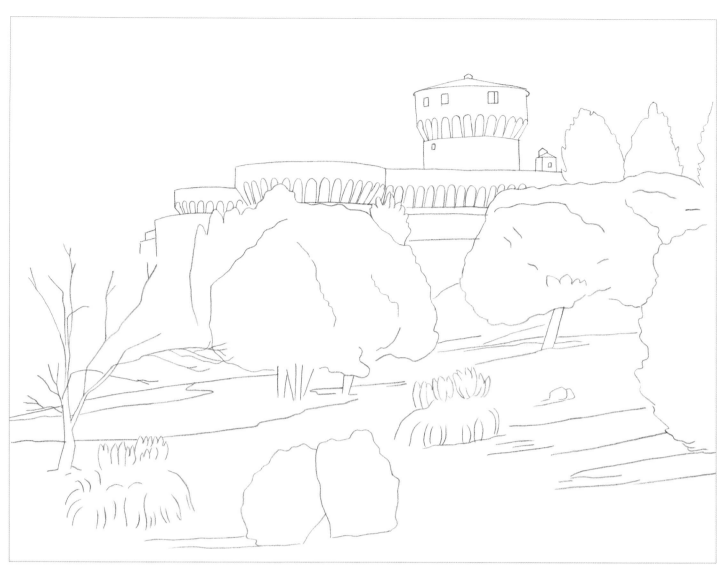

3. *Because this is a complex drawing, I approach the tracing step in two parts. To begin, I tape a clean piece of tracing vellum to my original "blueprint" drawing. I redraw the tree on the left, the cast shadows on the lawn, and simple outlines of the pampas grass, foliage, and trees. I begin refining the castle, drawing the outline and adding windows. I detach this piece of tracing vellum from my original "blueprint" drawing. I then tape a new piece of heavyweight tracing paper to the piece of tracing vellum I just traced on, discarding my original "blueprint" drawing. I am now ready to draw a more highly developed outline on this new piece of tracing paper.*

4. *I redraw the castle on the new piece of tracing paper, adding a few additional windows and more detail to the roof. I work slowly on the arches, redrawing each more accurately. I then redraw the large pine trees in front of the castle, adding more detail. I draw the bare tree on the left with more branches and limbs. I work on the pampas grass, adding more detail to the plumes and the longer grasses. I redraw the shadows, the large bush in the foreground, and the rocks. Once I have completed the drawing, I transfer it to a clean piece of plate finish (smooth or hot-pressed) Bristol paper. I choose this ultra-smooth surface because it will be easier to work on the many details.*

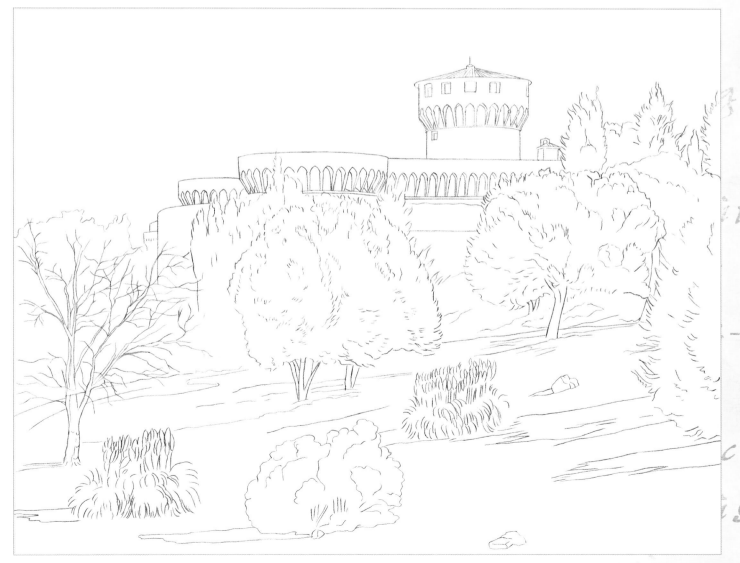

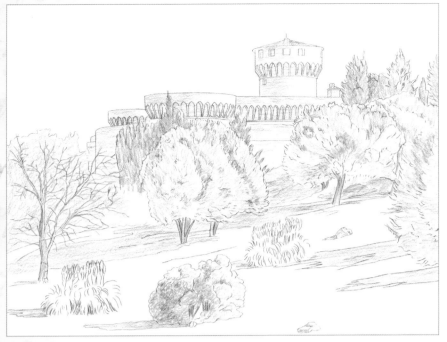

5. *Using the side of a 2B, I lightly add shading to the castle, using quick and loose strokes that follow the form. Still using the side of the 2B, but with heavier pressure, I shade the dark evergreen trees and ivy on the castle with loose strokes that follow the foliage growth. For the dark-toned tree on the right, I use longer strokes that turn upward. I work on the pine trees using a lighter pressure and changing direction of the short strokes to follow the growth of the branches and needles. I use heavier pressure in the deep shadow areas of the pine trees. I add tone to the base of the tower and, using long, horizontal strokes, shade the cast shadows on the grass. I add a light layer of tone behind the bare tree on the left, using circular strokes. I shade the large bush with circular strokes, using heavier pressure in the shadow area. Lastly, I add tone to the two rocks.*

6. *I continue building up the texture of the trees with a 2B. Using the side of the 2B, I add shadows to the pampas grass and deepen the tone of the cast shadows on the grassy area. With the dull point of a 6B and a sharp 2B, I build up the texture on the dark evergreens, using strokes that follow the direction of growth. For the ivy on the castle, I use circular strokes. I then work on the castle, this time adding dark shadows under the arches and in the windows. I use the side of the HB to do this and only use the point for the smallest details. I add texture to the castle by using light, irregular pressure with the side of a 6B. I work on details using a sharp HB. I then add texture by lightly lifting out tone with the kneaded eraser. I deepen the tone under the arches and in the windows with a sharp 2B.*

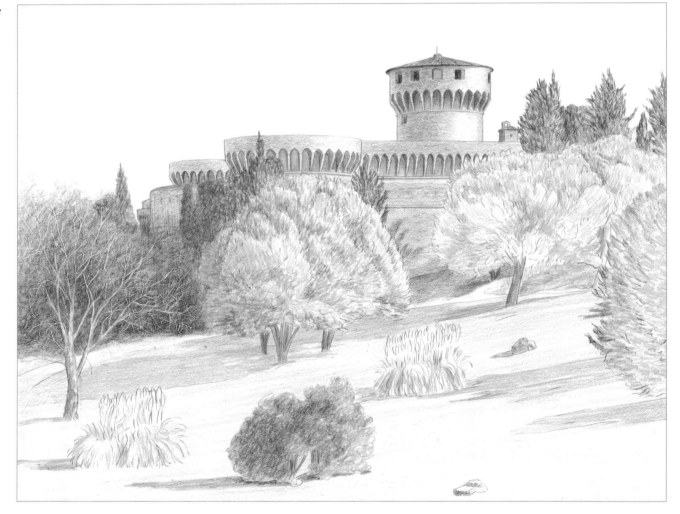

TREE DETAIL

To capture the texture of the bare tree, I use an eraser to lift out the lighter areas on the trunk and main limbs. I then apply an "indenting" technique. I find two nails: one small with a very sharp point and one large, with a duller point. I erase a section of the branches that I have drawn and leave the lightest "ghost" of the pencil lines. I then go over these lines with one of the nails, applying enough pressure to create an indentation in the paper. I use the smaller nail for the smaller branches, and the larger nail for the larger ones. Then, using the side of a 4B and 6B, I go over the indented section. The impressed lines from the nails will not pick up the graphite and will appear white. I continue working around the tree. When I am done, I deepen some shadow areas and pick up tone by lightly dabbing my kneaded eraser.

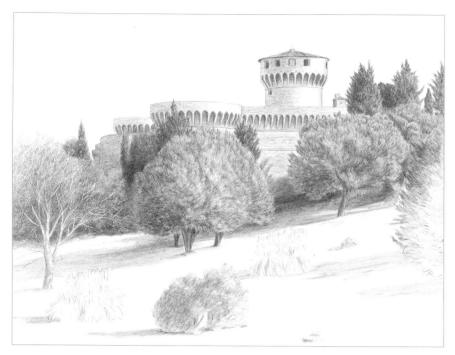

7. *Using the same technique as before, I deepen the tone of the dark evergreen trees in the background, this time using a 9B for the darkest areas. I also add deeper tone to the ivy. I use my kneaded eraser to lift out small areas to add more texture to both the ivy and evergreen trees. I then work on the large pine trees, using a sharp 4B and the 9B to add more shading and texture. I use a sharp 4B to darken the tree trunks. I deepen the shadows at the base of the castle with a 6B.*

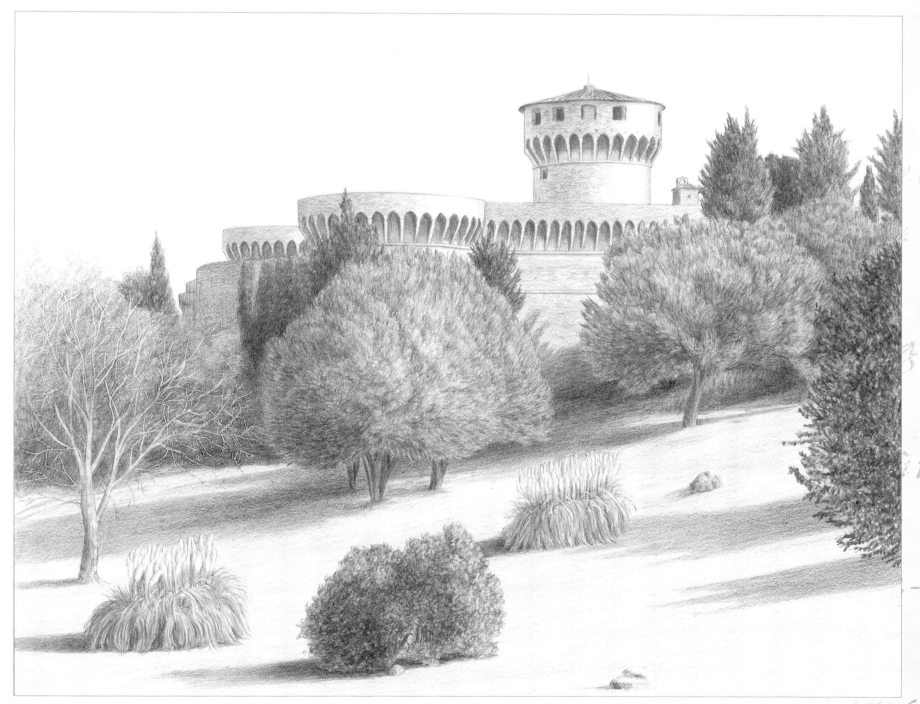

8. *I am now ready to pull the drawing together by working on the grassy area and the foreground elements. I use the side of a 6B to add more shading to the long cast shadows. I use the side of the 2B and long, horizontal strokes to shade the grassy area. I then use a kneaded eraser to pick out the plumes of the pampas grass. To add texture, I use a sharp 2B and long, curved strokes that follow their growth. I also use the kneaded eraser to lift out some grass texture as well. Next, I work on the large bush using a 4B and 6B with circular strokes, again lifting out some lights with the kneaded eraser. I add texture to the dark tree on the right using heavy pressure and the dull point of a 6B, as well as a combination of short and scribbly strokes. Finally, I add deeper tone to the arches in the castle with a sharp 2B. As always, I cover the drawing with tracing paper until I am ready to frame it.*

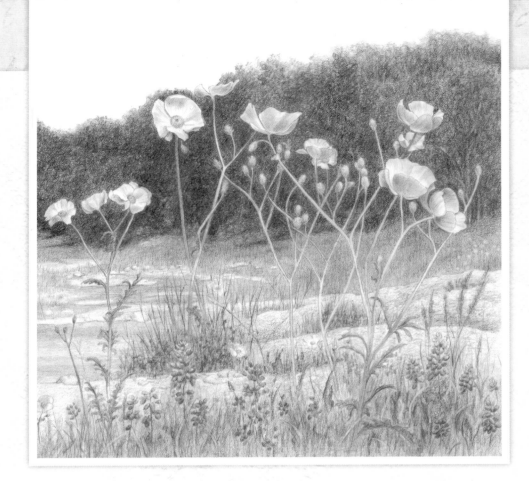

It should come as no surprise that landscapes are the most popular subject in art today. In our ultra modern world, a landscape provides our eyes and souls an escape from the ever-growing bombardment of high-tech living. But our job as artists is not to simply copy pretty scenery—our high-resolution cameras can do that far more accurately. Instead, we bring out the essence of natural beauty by relying on our feelings and sensitivities. In these pages, I have shared with you my approach to creating a landscape, from inspiration to execution. As you move forward to create your own landscape art, I encourage you to go through life with a sketchbook, a camera, and open eyes—you never know when the urge to draw the amazing world around you will strike.

DIANE CARDACI has been drawing and painting since she was a child. She developed her classical art training while studying at the Art Students League of New York City, Parsons School of Design, and the School of Visual Arts. Her passion for both realism and nature led her to start her professional art career working as a Natural Science Illustrator in New York City. Commissioned portrait work soon became an important part of Diane's artwork, and she is a Signature member of the American Society of Portrait Artists. She is also an award-winning artist, having exhibited her work both nationally and internationally. Her sensitive drawings and paintings hang in private, public, and corporate collections. Diane currently lives with her husband, Phil, in beautiful central Italy, surrounded by the hills and mountains of Umbria and Tuscany. Inspired by the amazing artistic heritage and the natural beauty of the area, she continues to follow her passions as an artist, author, and art educator. Diane's online gallery and blog can be seen at www.dianecardaci.com.